The Mildenhall Treasure
Richard Hobbs

THE BRITISH MUSEUM PRESS

First published in 2012 by
The British Museum Press
A division of The British
Museum Company Ltd
The British Museum
Great Russell Street
London WC1B 3DG

Reprinted 2022

britishmuseum.org/publishing

A catalogue record for this book is available from the British Library

ISBN 978-0-7141-5080-2

Designed by Bobby Birchall, Bobby&Co.
Typeset in MillerText and Berthold Akzidenz-Grotesk
Printed and bound in China by 1010 Printing International Ltd.

The papers used in this book are recyclable products and the manufacturing processes are expected to conform to the environmental regulations of the country of origin.

The majority of the objects illustrated in this book are from the collection of the British Museum. The British Museum object registration numbers are listed on page 64. You can find out more about objects in all areas of the British Museum collection on the Museum website at britishmuseum.org.

Author's acknowledgements
Thanks to Ralph Jackson, Jonathan Williams and Catherine Johns for their comments on various drafts of this book. Thanks also to my editor Carolyn Jones, Stephen Crummy for his work on the map and Axelle Russo-Heath for sourcing images.

I am pleased to acknowledge the support of the British Academy through the award of a British Academy Mid-Career Fellowship for the 'Mildenhall Treasure Project'. This book is one of a group of publications that will appear as a result of the award.

Contents

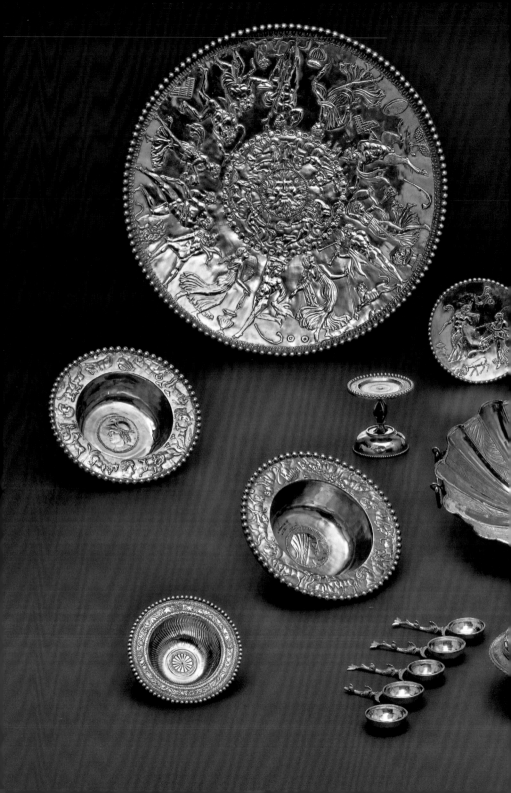

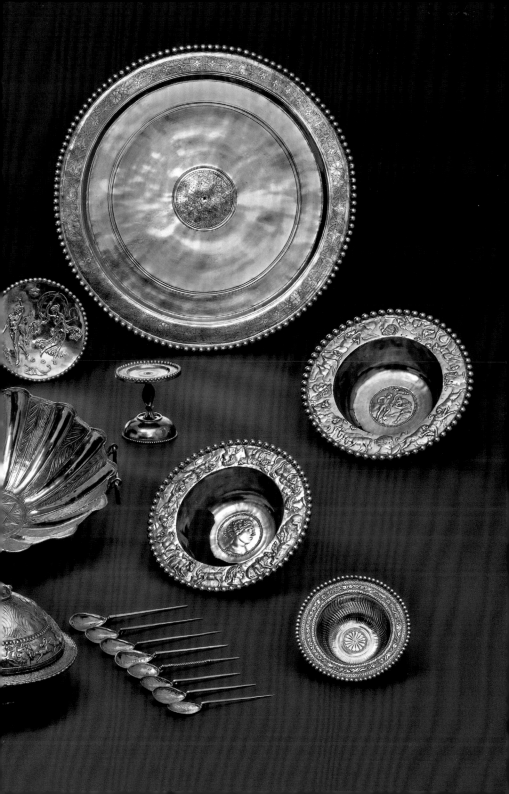

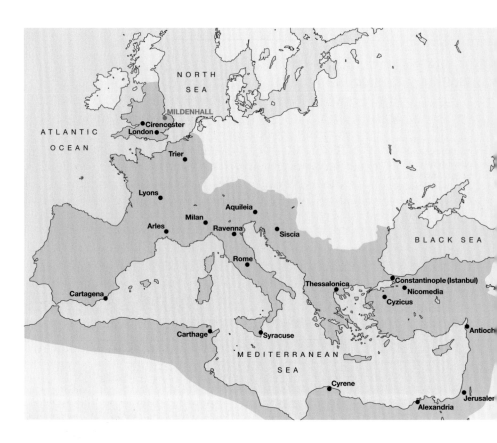

2 The Roman empire in the fourth century AD, showing some important provincial centres and the location of Mildenhall in Suffolk, eastern England. The area of the empire is coloured green.

Prologue

The Mildenhall treasure is Britain's finest late Roman silver dining service (fig. 1). It was discovered, buried in a Suffolk field, by a ploughman in 1942. Since it was first unveiled at the British Museum in 1946, millions of visitors have been captivated by its beauty.

This is the story of a veritable icon of what is often called Roman Britain's 'Golden Age', the fourth century AD. In the three centuries that had elapsed since the emperor Claudius' conquest of Britain in AD 43, Rome's most northerly province had prospered and the Mildenhall treasure is one of a number of examples of finely crafted metalwork that date to this time. Its decoration also provides a direct link between the world of Classical gods and the emerging world of Christianity, a religion that began to challenge belief in the old pagan deities of Rome and its provinces, Britain included.

Yet these were troubled times, too, characterized by political instability and civil unrest. We can speculate that the treasure's owners may have been caught up in these events, as they were probably members of the wealthy land-owning elite, perhaps even connected to the emperor himself. Even if the exact circumstances that led to the burial of their cherished silver service are unknown, the link to Rome's loss of Britain is certain; for the treasure was put into the earth around the time that Rome decided to abandon the island, and when the age of Anglo-Saxon England was about to dawn. The treasure lay buried and forgotten in a field, in the area that came to be known as Suffolk, and for over 1,500 years its bright silver surfaces slowly darkened until another period of great turmoil in British history flushed it out. This, then, is when our story begins, with the emergence from hiding of the Mildenhall treasure just after the end of the Second World War.

The discovery of the treasure

The reluctant Mr Ford

On 21 June 1946 Sydney Ford walked into the police station at Mildenhall in Suffolk a worried man. The local policeman Sergeant Cole, who'd known Ford for many years, asked what was troubling him. Ford confessed that some years earlier he'd discovered treasure, and was very concerned that he'd be in trouble because he hadn't reported it sooner. Sergeant Cole – it happened to be his birthday, so perhaps he was in jovial mood – sat down with Ford and a pot of tea and asked him to tell the whole story.

The next day Ford wrote to a friend, one Dr Hugh Fawcett, a General Practitioner based in Buckingham-shire (fig. 3). In the letter Ford told Fawcett, with obvious indignation, that Sergeant Cole had 'promptly come along and pinched the lot'. The policeman was probably not aware at the time that what he'd removed from Ford's house was the only set of silver Roman tableware ever unearthed on British soil and that its magnificent centrepiece, the so-called Great Dish, was a match for the finest metalwork from anywhere in the Roman empire. He also did not know that the price-less treasure had been sitting in Ford's

3 Dr Hugh Fawcett, a doctor and passionate antiquarian, who first alerted the British Museum to the treasure's existence.

house (the front door of which was 'never locked', family members later recalled) in the small Suffolk village of West Row near Mildenhall for almost four and a half years.

Three months earlier, on Easter Monday, Fawcett had paid Ford a visit. Both had an interest in antiquities, especially stone tools, and Fawcett had occasionally visited Ford during the Second World War to ask if he'd come across any flints or arrowheads that he might wish to sell. On that particular day Ford told him he didn't have any

new flints, but that he *did* have some old Roman pewter. Escorted into another room, Fawcett saw a collection of objects on the sideboard, which he later described as 'like a lot of wedding plate'. In the cupboard beneath Ford revealed the rest of the treasure. There were thirty-four separate pieces in total. Fawcett was dumbstruck: he knew straight away that this was not Roman pewter but silver, and explained to Ford that the discovery was almost certainly Treasure Trove (see p. 12) and must be declared immediately. Ford was reluctant. Fawcett later claimed that Ford had said to him, 'I'll not have anyone take it off me'.

Three weeks later Fawcett, his conscience haunted, reported what he'd seen to Christopher Hawkes, a curator at the British Museum and one of the most eminent archaeologists of his age. Hawkes instructed Fawcett to try to get his hands on some of the items so that they could be examined and analysed to make sure they were silver. Thus at the end of May 1946 the Museum got sight of an inscribed silver spoon and one of the dolphin-handled ladles (see p. 37), which Ford had reluctantly lent to Fawcett, although at this stage the Museum still had no idea who the owner was. By the end of the following month the treasure was in the hands of the local police.

The treasure's discovery

Although the police seized the Mildenhall treasure from Ford's house, he didn't actually discover it himself. In fact, it had been found by his employee, a local farmer called Gordon Butcher.

In January 1942 Butcher set to work ploughing a field on Thistley Green in the village of West Row near Mildenhall, Suffolk (fig. 4). As the field was to be used to grow sugar beet, he'd set the plough deeper than usual. (This may explain why the treasure had not been found previously, for the field had been turned over many times in the past.) Around 3 pm Butcher's plough struck something solid, causing the plough to break away from the tractor (see fig. 7). He started to dig around, expecting to find the remains of a buried tree stump, but instead of a large chunk of wood he came upon a circular piece of

4 Suffolk farmer Gordon Butcher, who discovered the treasure while ploughing in 1942.

blackened metal. Sensing that he'd discovered something unusual he decided to fetch his boss Sydney Ford.

As the light faded and a snowstorm swirled around them, Ford and Butcher spent the rest of the afternoon pulling pieces of silver out of the ground and placing them in a sack. In subsequent years, the children's writer Roald Dahl in his story 'The Mildenhall Treasure' (see fig. 35) presented the following imaginary exchange between the two men after they'd finished their excavation:

> Ford gathered the top of the sack in his hands, then bent down and picked up the large plate. He checked, stood up again, and holding the sack in his hands, looking to one side, he said,
> 'Well, Gordon, I don't suppose you want any of this old stuff.'
> No answer.
> 'I don't suppose you'd mind if I took it along home. You know I'm sort of interested in old stuff like this.'
> Gordon Butcher's blue-white face turned slowly towards the bulging sack.
> 'Of course,' he said very quietly. 'You take 'em along, Mr Ford.'

Although this is an entirely fictional conversation, it seems likely that Butcher did indeed allow his boss to take the whole of the treasure home and thought nothing more of it (Dahl's story was based on an interview he conducted with Gordon Butcher in 1946).

Sydney Ford was an agricultural engineer, and in the annex to his house he had a workshop where he repaired farm machinery. Over the next months, which soon turned into years, he spent his spare time carefully cleaning the silver, which had become tarnished and blackened after lying in the ground for hundreds of years. It is not known exactly how he did this – we can imagine that he used something abrasive, perhaps wire wool, and maybe some form of silver polish. There is also the disturbing possibility that he took more extreme measures: microscopic examination of the silver surfaces years later suggested the use of heat to remove the hardest corrosion. At the inquest into the discovery, Ford stated that the Great Dish (see fig. 10) took him 'nearly two years' to clean. That he spent so much time cleaning the silver tells us that it must have been a labour of love.

As each piece was restored to its former glory, or at least to a standard that met with his wife's approval, Ford brought the treasure into the house and placed it on the sideboard. A photograph taken in about 1944 (fig. 5)

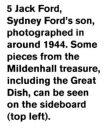

5 Jack Ford, Sydney Ford's son, photographed in around 1944. Some pieces from the Mildenhall treasure, including the Great Dish, can be seen on the sideboard (top left).

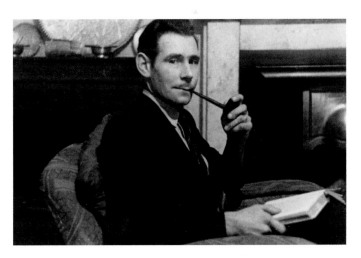

7 Opposite Silver flat-rimmed bowl from the Mildenhall treasure. The visible damage may have been caused when it was struck by Gordon Butcher's plough. Diameter 30 cm.

shows Ford's son Jack sitting in a chair smoking a pipe: look closely and you see that behind Jack on the sideboard is the Great Dish, the two Bacchic plates and the pair of small flat-rimmed (flanged) bowls, with what appear to be silver spoon handles sticking out of them. The treasure was not something just to be admired – it was also brought out and used on special occasions. Sydney Ford Jnr, Ford's grandson, told the BBC many years later that the Great Dish was used as a fruit bowl at Christmas, with 'apples, oranges, pears and nuts arranged in a pyramid', and that his grandfather used one of the spoons 'every day for his breakfast and dinner'.

An overnight sensation

After Ford had reported the discovery in June 1946, a coroner's inquest had to be held. At the time of the discovery, all ancient finds of gold or silver in England and Wales were subject to the common law of Treasure Trove. The law, which was replaced in 1996 by the Treasure Act, allowed the Crown to claim any discoveries of treasure if a legal owner could not be traced. However, in order for a discovery of gold or silver to be declared Treasure Trove, it had to be demonstrated at the inquest that there had always been an intention to recover the buried objects. In the case of the Mildenhall treasure there was no evidence to show that the original owners had not intended to recover their precious possessions, so a verdict of Treasure Trove was a foregone conclusion, and the aims of the inquest were rather to establish the date of the silver, who had found the hoard and if the finders should receive a reward.

6 Police officers unloading the Mildenhall treasure from a van for the coroner's inquest in July 1946.

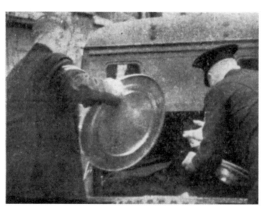

The inquest was held on 1 July 1946 at Mildenhall police station (fig. 6). A jury of twelve local men, chaired by the local bank manager Robert Pizzey, first heard testimonies

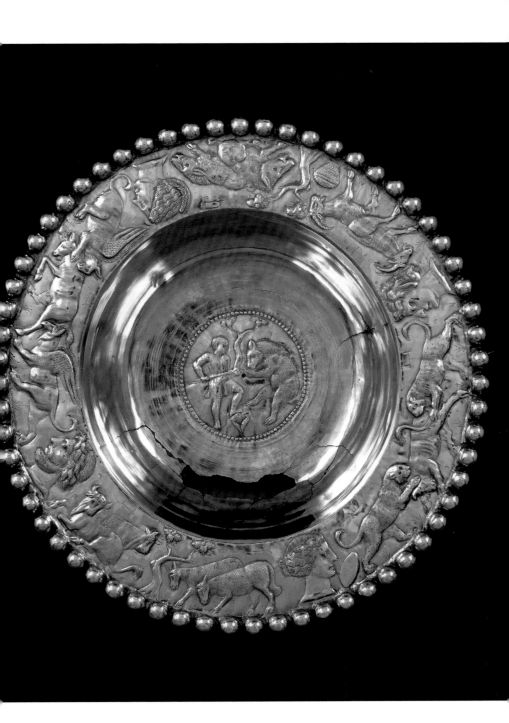

13

from Ford, Butcher and Fawcett. Curators from the British Museum and local archaeologists then offered their expert opinions, confirming that the treasure was made of high-quality silver and was likely to be of late Roman date, i.e. the fourth century AD. Ford insisted throughout the inquest that he had always believed the hoard was made of pewter, perhaps fearful that if he admitted he had known it to be silver he would be in trouble.

The jury decided that the treasure was indeed Treasure Trove and a few weeks later it was transported to the British Museum under armed guard. The treasure was an overnight sensation when it went on display: the *London Evening News* complained that 'Hundreds do not see treasure', such was the throng to view the discovery. One visitor, Reginald Carter, wrote to the *East Anglian Daily Times* to observe that he'd seen forty people viewing the treasure in the space of half an hour, which had included a group of 'five Cockney boys, one of whom proudly remarked "Blimey Pete, that stuff's werf a million quid!"'. Although the treasure was probably not worth quite that much at the time, Butcher and Ford each received a reward of £1,000, a considerable sum of money then, although rather less than they might have received if the find had been reported immediately. *The Daily Herald* broke the news of the reward to Butcher who, though naturally delighted, did point out to the reporter that he was rather busy as he had 'the cows to feed'.

Conspiracy theories and the Mildenhall treasure

Doubts, however, soon began to surface as to the 'true' circumstances surrounding the discovery of the Mildenhall treasure. Ford was asked to show a number of different people where the treasure had been found. He took one archaeologist to a spot on one of his own fields, but this was different to the place he'd shown the police. Later he pointed out two different locations on a field belonging to his neighbour Mr Rolfe. A pair of experienced local archaeologists, Gordon Fowler and Tom Lethbridge, then investigated another find-spot on Mr Rolfe's land which they were shown by Ford just before the Treasure Trove inquest. They found neither evidence that the soil had

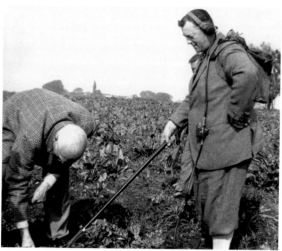

8 Archaeologists Tom Lethbridge and Gordon Fowler trying to locate the original find-spot in around 1947.

been disturbed nor traces of a burial pit. A few months after the inquest, they asked Ford to show them the find-spot again, and this time he led them to yet another place (fig. 8). Upon digging, and using primitive metal detectors, they again found no traces that the soil had been disturbed, although they did discover some further pieces of shiny metal – which turned out to be parts of a Georgian teapot. Fowler and Lethbridge believed that the teapot fragments had been planted, and began to suspect that the treasure had not been found at Mildenhall at all.

One theory – still mentioned occasionally today – was that the treasure had been found in North Africa during the Second World War. The archaeologist Charles Phillips (famous for his excavation of the main burial mound at Sutton Hoo) wrote in his autobiography:

> . . . there was the possibility that [the Mildenhall treasure] might have been found during military activity in North Africa, smuggled back in a plane and temporarily hidden on the edge of the airfield, accidentally found by Ford, and removed by him before those who had imported it had been able to take any action.

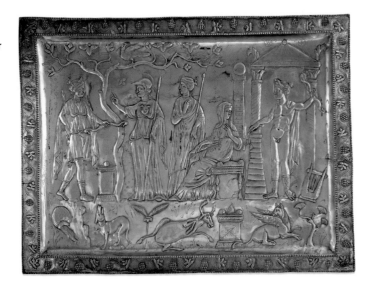

9 The Corbridge Lanx, a fourth-century silver platter found on the banks of the River Tyne in northern England in 1735. Length 50.3 cm, width 38 cm.

The airfield at Mildenhall that Phillips mentions is still used by the military today (it is now an American airbase, although at the time of the discovery it was used by the RAF).

In retrospect, it seems far more likely that Ford either genuinely could not remember where the treasure had been discovered – after all, four and a half years had elapsed between the discovery and the inquest – or he decided to have a bit of fun with the authority figures of his day: Lethbridge, for example, was a lecturer at Cambridge University, so very much part of 'the establishment'. Also, with the benefit of hindsight, we know that there was another reason why archaeologists of the time had their doubts. What, some experts began to ask themselves, was such magnificent treasure doing in a muddy field in Suffolk? At the time nothing quite this spectacular had ever been found in Britain, and many viewed the Roman province of Britannia as rather dull and impoverished in comparison to the inspiring remains visible in parts of the Mediterranean. One or two other pieces of Roman silver had been found in Britain before – for instance, the Corbridge Lanx, a splendid rectangular

silver platter, discovered in 1735 and now in the British Museum (fig. 9) – but never a complete dining service.

However, discoveries since the Second World War have shown that, in fact, the finding of such a treasure in this particular part of Britain is not as unusual as was once thought. Other Roman gold and silver treasures from Water Newton in Cambridgeshire, Thetford in Norfolk and particularly Hoxne in Suffolk (see fig. 37) – the largest hoard of Roman gold and silver ever found on British soil – have demonstrated that East Anglia is rich in Roman precious metal hoards in relation to the rest of the country and, indeed, the empire as a whole. So, even though we do not know exactly where the treasure was discovered, we have no reason to doubt that it was unearthed near Mildenhall by Gordon Butcher and Sydney Ford on a wintry Suffolk day in January 1942.

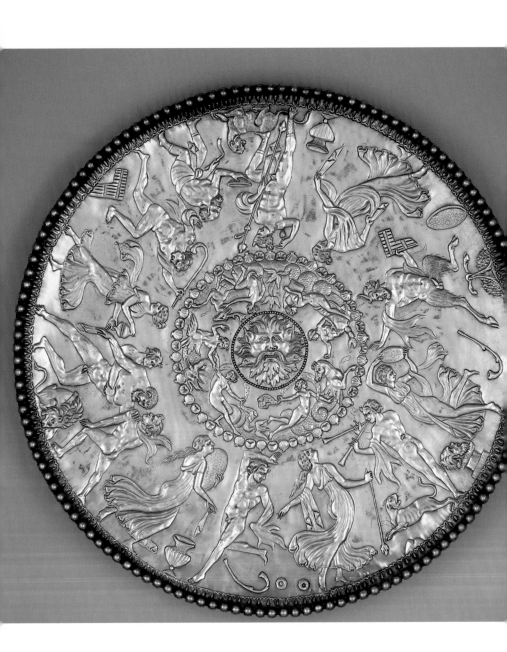

Chapter Two
The Great Dish and the Mildenhall treasure

10 Opposite The silver Great Dish, the centrepiece of the Mildenhall treasure. Diameter 60.5 cm.

11 Below The head of a sea-god in the centre of the Great Dish.

A masterpiece of Roman silverware

By far the most magnificent item in the Mildenhall treasure is the Great Dish, which dates to the fourth century AD (fig. 10). Better termed a platter, it is an enormous disc of very pure silver, over 60 cm in diameter, and weighing over 8 kg (about 25 Roman pounds). It is slightly dished, has a distinctive rim of continuous beads and sits on a circular foot-ring. Its size is remarkable, but it is the decoration across its entire upper surface that elevates it into a masterpiece of Roman craftsmanship.

Starting at the centre we find the head of a sea-god, either Oceanus or Neptune, both of whom had dominion over the seas and oceans (fig. 11). The sea-god has large, staring eyes, a long drooping moustache and a beard made of seaweed. Heads of four dolphins emerge from his hair and beard, giving the sense that he is the father

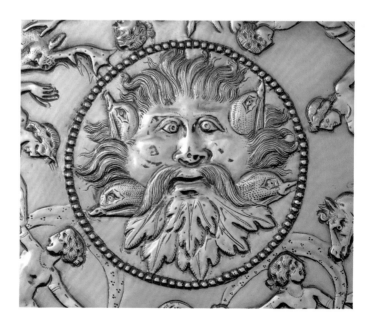

19

of all sea creatures, dolphins being the most elegant and intelligent of all. In the next decorative band the sea-god is surrounded by his domain, the waters of the world, or perhaps the Mediterranean Sea, literally the 'sea in the middle of the lands'. It was domination of the Mediterranean Sea that gave the Roman empire its power, for the control of sea-borne trade was immensely important to Rome's economic success.

The edge of the 'sea' is defined by a ring of scallop shells. Between this ring and the circle of beads surrounding the head of the sea-god are four separate but quite similar scenes. Each depicts a Nereid, a beautiful young sea maiden, with wavy hair tied in a bun and naked except for a necklace, arm bangles and a long sash held in her hand. Each Nereid either sits astride or hangs onto a mythical sea-creature, one pair of which combine a fish with an animal: the first a mythical sea-monster known as a hippocamp, with a long curling three-pronged tail and the head of a horse; the second with a similarly fishy lower body but the upper half of a stag. The most complex scene shows a Nereid astride a sea-monster with a long thick neck and the head of perhaps a hound, although sometimes it is called a dragon. The creature's head is turned back in the direction of its female rider, while in front of the monster is a creature with the lower half of a fish and the upper body of a lithe male youth with a long crab's claw extending from the front of its body. He is looking back towards the Nereid and grasps her gently by the elbow. The final Nereid reclines on the lower body of another half-man, half-fish, who has a wing instead of a crab's claw at the front; she leans on an object that resembles a casket or perhaps a musical instrument.

Who are these strange creatures? They appear to have little to do with the reality of marine life. Long before underwater exploration and our modern, scientific understanding of tides, currents and winds, the sea was a place of mystery, which was unpredictable, wild and dangerous. Thus mythology stepped in to explain how the realm of the sea-gods was populated and organized. Nereids were nymphs, female divinities of the sea, patrons

of sailors and fishermen, and custodians of the sea's riches. There were male gods too, such as Triton, the son of Neptune, a figure of whom forms the handle of the covered bowl (see pp. 34–5). From ancient Greek times Triton was depicted as a merman, sometimes bearded, or youthful, with the upper body of a man and the lower body of a fish. Although the inner frieze of the Great Dish does not depict Triton exactly, the half-men, half-fish creatures bear similarities to him. The other creatures, such as the hound-headed monster, might be based on sightings of whales or giant squid – with a little imagination it was very easy for sailors' fleeting descriptions of enormous animals emerging from the ocean depths to be transformed into fantastical creatures.

Although the inner zone of the Great Dish concerns the sea, the greater part is devoted to an entirely earthbound scene that occupies the whole of the wide outer frieze (fig. 10). In this sense the centre of the vessel *is* the sea – again, perhaps the Mediterranean – and the larger outer part of the vessel the lands that surround it. Thus the Great Dish could be viewed as a simplified representation of the entire world – or at least the world known to the Romans.

The decoration in the outer frieze is again drawn from Classical mythology. In order to 'read' the scene, we have to orientate the dish correctly. If the dish is turned so that the head of the sea-god in the centre is the correct way up, then the 'narrative' begins directly above him – at 12 o'clock, if we imagine the dish as a clock face. Here then is the principal figure, Bacchus, the god of wine and abundance,

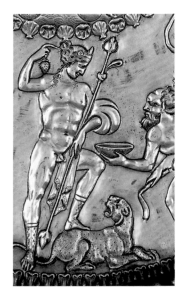

12 The god Bacchus and his panther. Bacchus is the principal figure of the Great Dish's outer frieze.

and bringer of fruit and blossom (fig. 12). We know he is Bacchus because he has a number of distinguishing characteristics, which are known as his 'attributes'. All deities have attributes that make them identifiable, just as Che Guevara is instantly recognizable from his military beret with its gold star and his shock of black hair. Bacchus is naked with a muscular torso and well-kempt hair – he

is youthful and rather effeminate, but is nonetheless dignified and worldly. He holds a bunch of grapes in his right hand and in his left a *thyrsus*, a staff tipped with a pine cone. He rests his left foot on the haunches of a panther, his ever-present companion, and behind his standing leg is an urn. Silenus, an elderly Satyr (one of the male attendants of Bacchus and his wise teacher),

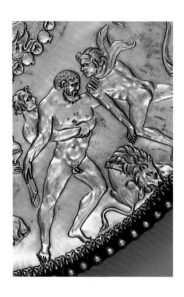

bows before the god with a bowl in his hand, requesting refreshment, while to his left dances a heavily draped Maenad, one of Bacchus' female devotees.

Moving around to about 8 o'clock we find another famous figure from Classical mythology, Hercules (fig. 13). He is very different from Bacchus in appearance: older, bearded, much more bulky and muscular with a bull-neck. Hercules also has his attributes, including the skin of the Nemean lion (killed as one of his famous Twelve Labours). It lies discarded at his feet, wrapped around his distinctive wooden club. Hercules does not stand in a dignified pose, like Bacchus: he is clearly blind drunk, and has to be supported by two Satyrs to stop him from collapsing in an inebriated heap.

13 Hercules with his lion-skin at his feet. A detail from the Great Dish's outer frieze.

And this gets us to the heart of the narrative, a famous story in the myth of Hercules, in which the hero has taken on Bacchus in a drinking contest and has come out the worse for wear. A fairly predictable outcome perhaps – it's never wise to take on a god at anything and certainly not at what he does best. Even Hercules, the epitome of masculinity, is unable to hold his drink.

The rest of the outer frieze is a riot of frenzied activity. All it lacks is a soundtrack, and music indeed played a significant role in the worship of Bacchus. Between Bacchus and Hercules (at 10 o'clock) a naked Satyr brandishing a *pedum* (a herdsman's hooked staff) above his head is running full pelt over an abandoned *syrinx* (a set of pan-pipes) towards a Maenad, who, seemingly unperturbed, skips on tiptoes as she brings a pair of cymbals clashing together. On Hercules' other side (at

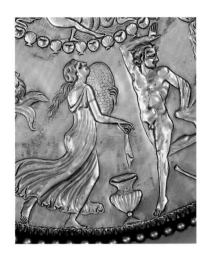

7 o'clock) are another Maenad and Satyr: she wears a long flowing dress, the end of which she holds in her hand, while the other clasps an object to her bosom (fig. 14). Is it a large metal platter, similar to the Great Dish itself, or a musical instrument, perhaps a tambourine? It is not clear – sometimes what the craftsman intended is open to interpretation. The Satyr dances towards her but turns his head over his shoulder, as if distracted by events behind him. A *nebris* (goatskin) is wrapped around his arm and a *pedum* (staff) has been dropped to the ground. Further round at 4 o'clock, a Satyr plays a double flute directly into the face of his Maenad companion, who throws her head back in ecstatic delight. She has dropped a pair of cymbals to the floor, perhaps the cause of the distraction of the Satyr in the neighbouring scene. At their feet Bacchus' playful panther has joined in the fun. Last but not least at 3 o'clock is the god Pan, half-man, half-goat, god of flocks and shepherds, mountain wilds and rustic music. He holds his famous pan-pipes as he skips away from a Maenad, dancing as she shakes a tambourine, her split dress provocatively revealing her legs. On the ground below is a bust of Silenus on a pedestal, as well as another abandoned staff, and beneath Pan's feet grapes tied up in a goatskin.

14 A Maenad and a Satyr, dancing, depicted on the outer frieze of the Great Dish.

The meaning of the decoration on the Great Dish
The cult of Bacchus was hugely popular across the Roman empire, including Britain, from the evidence of archaeological discoveries. His worship can be dated back to at least the eighth century BC, so by the time the Mildenhall Dish was produced his cult had been going strong for well over a thousand years. His enduring popularity is not surprising given that his rites involved the drinking of wine, the playing of music and dancing – activities which are still central to the cultural life of many societies. It was said that as a young god Bacchus travelled widely, including to India; sometimes he is shown

with a tiger instead of a panther in reference to this visit. Where he was well received, mortals were rewarded with the gift of viticulture (vine-growing). But where he was not welcome, retribution was paid. His Maenads were said to have torn King Pentheus of Thebes limb from limb when he outlawed Bacchic worship, while King Lycurgus of Thrace suffered torment and death after attacking one of Bacchus' Maenads, a scene depicted on the fabulous Lycurgus Cup, also in the British Museum (fig. 15). The Roman state had a love-hate relationship with the Bacchic cult. The Senate, appalled by the excesses of his worship, imposed a ban in 186 BC, but other senior Roman figures, such as Julius Caesar, were active cult followers.

So the main outer scene of the Great Dish depicts a Bacchic revel, coupled with a comic narrative of the drinking contest between Bacchus and Hercules. Thus in addition to Bacchus himself we see his *thiasos*, the supporting cast of human and mythical cult followers. The Maenads (or Bacchantes) were his sacred women, depicted as young, voluptuous maidens, dancing and playing music. It was said that when the Maenads struck the ground with their staff (the *thyrsus*), wine would flow forth, but it was also said that the Maenads had a darker side, able to wreak havoc when they were in an inebriated frenzy. Their male equivalents, the Satyrs, were rustic fertility spirits, and are often depicted, as on the Great Dish, with pointed ears, small horns and a little tail like that of a goat or a horse (most obvious on the Satyr playing the double flute). They were also highly sexed, and are often shown chasing the Maenads with amorous intent – in many ways they represent the animalistic side of human nature. But among all the music-making, dancing and wine-drinking, there is one detail not to be overlooked: the theatrical mask of Silenus sitting on a pedestal looking up at the scene. This is important, because drama was integral to the worship of Bacchus. The most famous play about him is *The Bacchae*, by the ancient Greek playwright Euripides. The play dramatizes the tragic story of Pentheus, and in it Euripides talks of the 'pleasure from wine that banishes grief'. All drinkers are aware of the transformative effect of wine

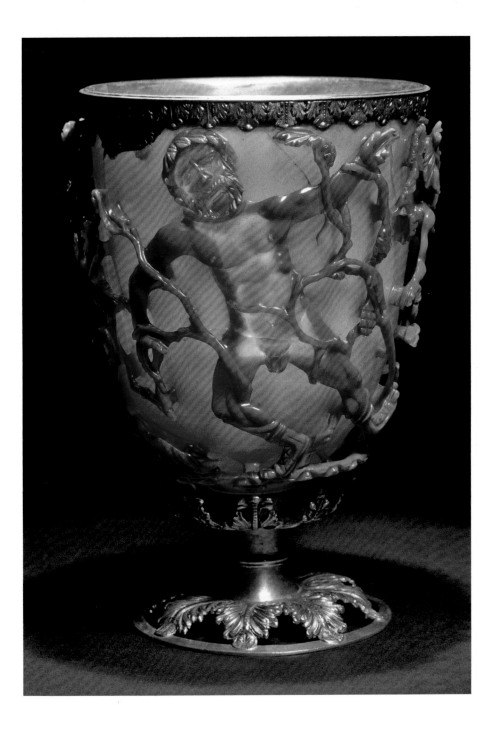

25

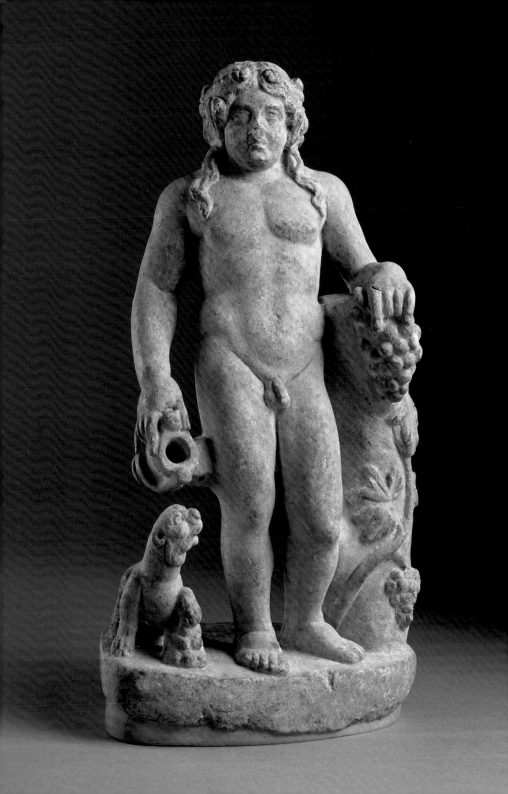

and other spirits, which can make people behave not quite like themselves, akin to actors in a play. So the scenes are imbued with theatre and humour, such as the way in which the Satyrs flirt with and chase the Maenads in a comic, slightly ridiculous manner, with no malicious intent.

The Great Dish is not just telling us that Bacchus, the god of wine, holds wild and drunken parties. Bacchus was also a fertility god, particularly connected to the fertility of plants, and central to his myth were the eternal cycle of life and the dynamic yearly rebirth of nature. Thus the rituals that developed around him may appear on the surface to be about drunken debauchery, but they were also a formalized and ecstatic way of honouring the god to ensure that plants would grow, that the grape harvest would be healthy and that the crops would not fail. Thus in a wider sense the Great Dish is concerned with the bounty of earth and sea and, as it was the centrepiece of a silver dining service, the decoration was perhaps a reflection of what the owner himself served to his guests, a subject more fully discussed in the next chapter.

However, there is also a spiritual aspect to Bacchus, which became increasingly significant over time, and may have been of principal importance by the time that the Great Dish was created. Throughout the course of the Roman empire, Bacchus remained tied to wine and theatre, but he also came to be regarded as a god of personal salvation. His cult was one of a number of 'mystery cults' that sprouted up around the empire and which, like Christianity, had personal salvation at their core. Archaeological evidence, such as a statuette of Bacchus from Spoonley Wood in Gloucestershire (fig. 16), buried with its owner, suggests that many believed that Bacchus was able to lead the soul to paradise. It may be, therefore, that the scene on the Great Dish also represents the journey of the soul from the earth (outer frieze) across the sea (inner frieze), to the Islands of the Blessed, the Elysian fields of Greek and Roman mythology, represented by the sea-god (centre). Those who admired the decoration on the Great Dish over 1,600 years ago may have had in mind all or some of the themes outlined above.

27

17, 18 Below and opposite Pan and a Maenad blowing into musical instruments; details from one of the Bacchic plates.

19 Following pages The two silver Bacchic plates. Diameter 18.5 cm.

The rest of a remarkable dining service

The Bacchic theme continues on a pair of smaller vessels also of fourth-century date (fig. 19). Generally known as the 'Bacchic platters', they are in fact small, slightly concave plates, each about the size of a modern dessert plate. They are so similar in design to the Great Dish that we can be sure they were fashioned in the same workshop and belong with their larger counterpart. One shows Pan turning towards a bare-footed Maenad, ostentatiously dressed in an ankle-length pleated skirt, a frilly bell-bottom top and a long scarf that billows out behind her. Above them in the background reclines a bare-breasted sea-nymph (a Nereid), a further echo of the Great Dish itself, as water

flows from a jug on which she leans. The music-making, too, continues, for Pan is playing his famous pipes while the Maenad blows into a double-flute (figs 17, 18).

On the other small plate (fig. 19, left) is a Maenad identically dressed, perhaps intended therefore to be one and the same. She is dancing, holds a staff across her body and shakes a tambourine. To her left is a Satyr, who appears to have cast away his pan-pipes and regards the Maenad as if he has been slighted – she dances and rattles her instrument regardless. Between them is a skin full of grapes, once more echoing a similar skin shown on the Great Dish, as does a pair of discarded cymbals that lies beneath their feet.

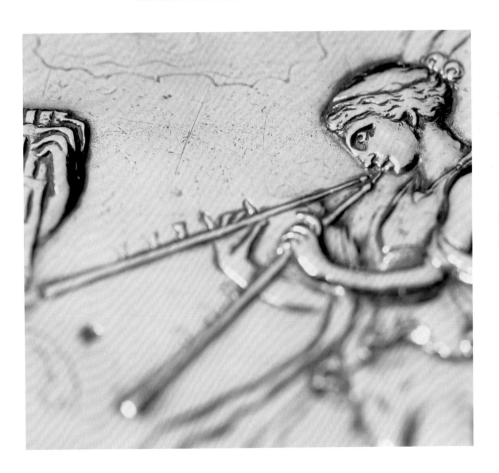

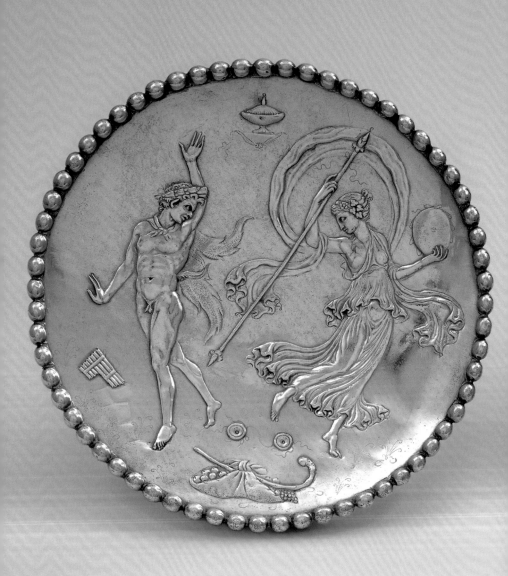

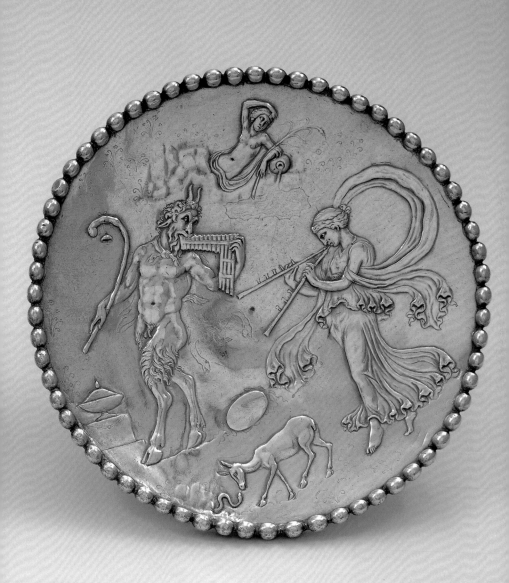

20 One of the four
large, flat-rimmed,
deep silver bowls.
This one is decorated
with the head of
Alexander the
Great in the centre.
Diameter 26.8 cm.

The treasure contains other dining vessels, still
largely Bacchic in theme, and also mostly made in the
fourth century AD. A matching set of four deep bowls
has decoration on their flat and beaded rims and in
the centre of their bases (figs 1, 7, 20, 21). In a series of
vignettes separated by male and female theatrical masks
are shown real and mythical animals in various stages
of life and death. Some scenes are peaceful and pastoral,

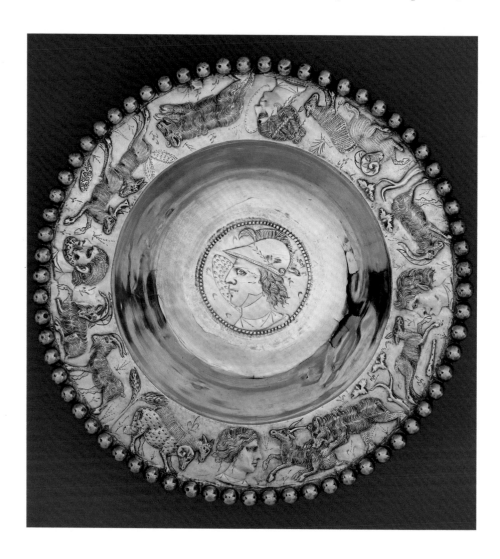

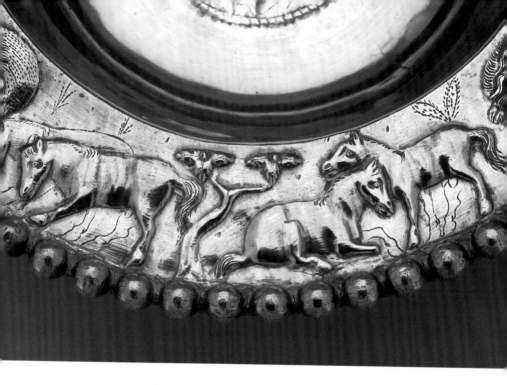

such as grazing sheep and a pair of horses affectionately nuzzling their necks (fig. 21). Yet danger lurks around the corner: a creature resembling a leopard chases a pair of antelope and two lionesses bring down a bull (fig. 7). In other scenes the hunt is over and the animals feast on the carcass: a pair of hyenas sink their teeth into a dead antelope. In the base of one of the bowls the hunting theme is mirrored as a hunter spears a bear, but in the other bases there are allusions rather to Alexander the Great, legendary conqueror of Persia. Alexander's helmeted head is shown in one (fig. 20), his mother Olympias in another. The last is a portrait of another woman, perhaps another of Alexander's relatives.

There is also another pair of smaller flat-rimmed bowls (see fig. 1, bottom left and right) and a pair of small flat plates (fig. 22). Originally thought to be goblets because of their convex bases and elaborate decorated stems (in earlier publications they are shown 'upside down'), they are certainly small plates with beaded rims

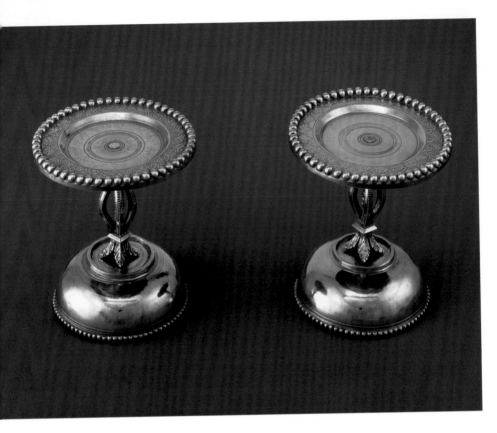

22 The pair of small silver plates on bowl-shaped bases. Height 11.7 cm.

which sit on hemispherical bases. In any case glass was mainly used for drinking utensils by the fourth century AD, as contemporary depictions show (figs 31, 32, 33).

The covered bowl (fig. 23) is decorated with further hunting scenes, although the style of the decoration is so different from the other pieces that it is likely to have been made at an earlier date and probably in a different workshop. To complicate matters further the lid does not fit the bowl, so the two parts were evidently made separately, the bowl probably in the third century AD and the lid perhaps half a century later. The scenes on the lid involve a confrontation between a centaur (half-man, half-horse) and a wild animal, imagery which can also be tied to Bacchus, for centaurs were associated with the god and indeed the masks which frame these scenes

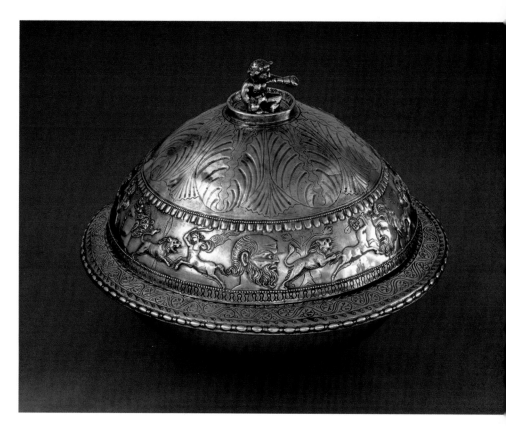

23 The silver covered bowl, with hunting scenes and Triton handle. Height 19 cm.

include heads of Silenus, Pan and probably Maenads. The top of the lid is surmounted by the figure of Triton blowing his conch shell. This is not the original handle, so was added at a later date.

The Mildenhall treasure contains another large platter, normally referred to as the Niello Dish, but unlike the Great Dish its flat upper surface is almost entirely plain (see fig. 29). Its only decorative zones are a central medallion and a narrow outer frieze inside its beaded rim. Rather than being raised into relief (see p. 41) as on the Great Dish, its geometric decoration is incised into the surface, although – and here is another difference – the grooves are filled with a black silver-sulphide paste known as niello, designed to create a contrast with the silvery background.

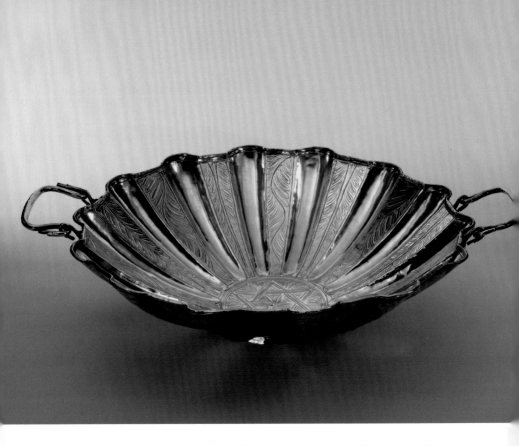

24 The silver
fluted bowl
with swan-head
drop handles.
Diameter 40.8 cm.

A large fluted bowl with swan-head drop handles
completes the service (fig. 24). Its flutes are decorated
with incised leaf-like tendrils alternating with plain flutes,
and in the centre of the base is a neatly incised six-pointed
star formed by two interlocking triangles. People often
suggest it represents the Star of David, a symbol that has
become synonymous with the Jewish faith. This can be
entirely discounted, however, for the device was not used
as an official Jewish symbol until the seventeenth century,
although it may have had a magical meaning at various
times during antiquity, including the period when the
Mildenhall treasure was made.

Just as a modern dining service includes plates and
bowls but also cutlery, the final elements of the treasure
are not vessels but dining utensils, in this case ladles and

spoons. There is a matching set of five ladles with deep circular bowls and gilded silver handles in the form of dolphins, their eyes originally inlaid perhaps with coloured glass or even precious stones (fig. 25). There are also eight spoons with long pointed handles (fig. 26). Three of the pear-shaped bowls are decorated with leaf-like motifs, which echo the decoration on the fluted bowl. The rest of the spoons bear the only inscriptions in the whole of the treasure, except for a few instances of scratched graffiti (see p. 46). Two form a pair, and provide us with names: one reads 'PAPITTEDO VIVAS', the other 'PASCENTIA VIVAS' (see fig. 26, the circled spoons). Papittedo is a man's name, Pascentia female, and the Latin word *vivas* means 'may you live', so can be read as something like '(Papittedo/Pascentia) long life'. (Tom Lethbridge, the first archaeologist to examine the treasure at first hand, recounts an amusing story about these spoons. When he read out the names in Mildenhall police station, Sergeant Cole asked him to spell them so that he could diligently note them down. Maybe he thought Papittedo and Pascentia were still alive and well and living somewhere nearby!)

25 One of the five silver ladles with dolphin handles. Length 15.2 cm.

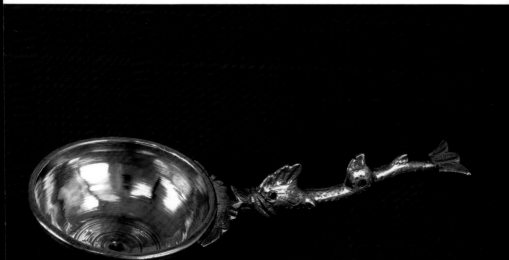

Some believe that the word *vivas* has a Christian meaning, or even that the spoons were Christening presents to Papittedo and Pascentia after they were baptised – *vivas* being used in the sense of a 'long life in Christ'. If this is the case, then they should be grouped with the only explicitly Christian objects in the treasure, the last three spoons. Each has a Chi-Rho symbol inscribed in the bowl, flanked by an Alpha and Omega (fig. 27). The Chi-Rho was used by fourth-century Christians to denote Christ himself, for it is a monogram composed of the first two letters of Christ's name in Greek. The Alpha and Omega, the first and last letters of the Greek alphabet, are a reference to a passage in the Book of Revelation in which Christ is described as 'the beginning' and 'the end'. Although this mixing of traditional Classical imagery –

26 The eight silver spoons. The pair of spoons incised with personal names are circled. Lengths from 16.3 to 20.6 cm.

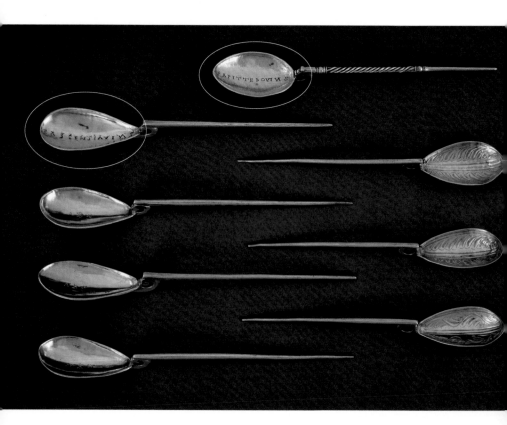

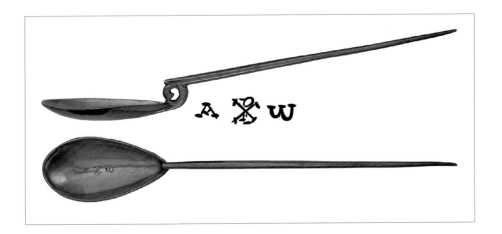

in this case Bacchus and his entourage – with Christian symbols might seem strange to us, it was quite common on metalwork, mosaics and other forms of art at the time. These spoons were almost certainly made after the emperor Constantine the Great (AD 307–37) officially ended the persecution of Christians in AD 312 and began actively to promote Christianity as the principal religion in the Roman empire.

Where and how was the treasure made?
It is not known where the silver used to make the Mildenhall treasure originated. Silver was mined in various places in the empire, for example the Sierra Morena mountains in Spain, and it was also a by-product of lead extraction, from places such as the Mendip Hills in south-west England. In any case silver was regularly recycled, by being melted down and reused, so even if it were possible to conduct a scientific test to establish the silver source – such a test has yet to be invented – this would not tell us where it was actually crafted. The second problem is that not all the objects were necessarily made in the same place: the style of the fluted bowl and the covered bowl is different from that of the Great Dish and the Bacchic plates, and so they almost certainly date to a different period and probably an entirely different workshop. Where exactly was this workshop? This we also

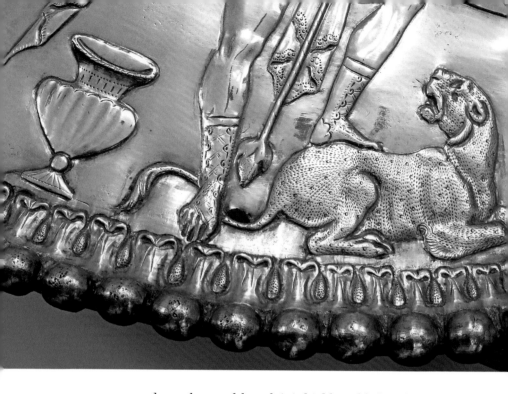

28 A detail of the beaded rim of the Great Dish, created using a special tool.

do not know, although it is highly unlikely to have been in Britain; more probably it was in one of the cities in which the emperor resided, for by the late Roman period the emperor and his court were no longer exclusively based in Rome (see p. 45).

Close examination of the vessels can, however, tell us how they were made. In the case of the Great Dish, over 8 kg of silver was cast into the platter's basic shape, including the foot-ring on which the platter stands. Once this shape had been created, the heated platter would have been repeatedly hammered, in order to form the required diameter, in a process that is technically termed 'raising'. The hammer marks left by raising are still visible on the back of the Great Dish, on close examination. The cast foot-ring would have also been raised and the rim thickened, probably by hammering the vessel side-on. The beads on the rim were formed by using a specially shaped tool hammered into the hot metal to create the spherical shape (fig. 28). We know that the same tool was

used all the way around the rim because the beads all have identical flaws. The rim would then have been turned over using a pair of tongs. It seems as if this process caused parts of the rim to crack, because unsuccessful attempts were made to fill in the gaps by casting on silver.

Next the Great Dish was decorated, using a metalworking technique known as 'chasing'. With the Great Dish resting on a supporting anvil, a series of metal punches and chisels, almost certainly of different gauges, were used to pare away the silver and to create a false relief. In the hands of an experienced metalworker, figures could be gradually brought to life from the metal surface. The plain areas on both front and back were then smoothed using a lathe, which would have fixed the dish centrally so that it could be rotated and polishing tools pressed against its front and back surfaces. The raised relief decoration was then burnished (polished) in order to make it shiny and smooth. Finally further details were added to the design using smaller tools to incise and punch the surface of the metal – for instance the goatskin worn around Pan's neck, or the scales on the fish-creatures' tails. Often these incised elements denote background, in order to give the various scenes perspective and depth.

We have no way of knowing how long this work would have taken, but it must have occupied a highly skilled and experienced silversmith, or perhaps even a small team, for a considerable time. Nor do we know for certain the intended final appearance: although the treasure is now displayed in its polished state, it may be that a tarnished appearance was originally preferred. Alternatively, it may be that the raised figures on the Great Dish were polished to bright silver and the undecorated areas left to darken naturally, which would have created a strong sense of perspective. In the flickering light cast by candles or oil lamps, so unlike the constant electric lights of today, the figures would have danced and shimmered across the surface, almost as if they were alive.

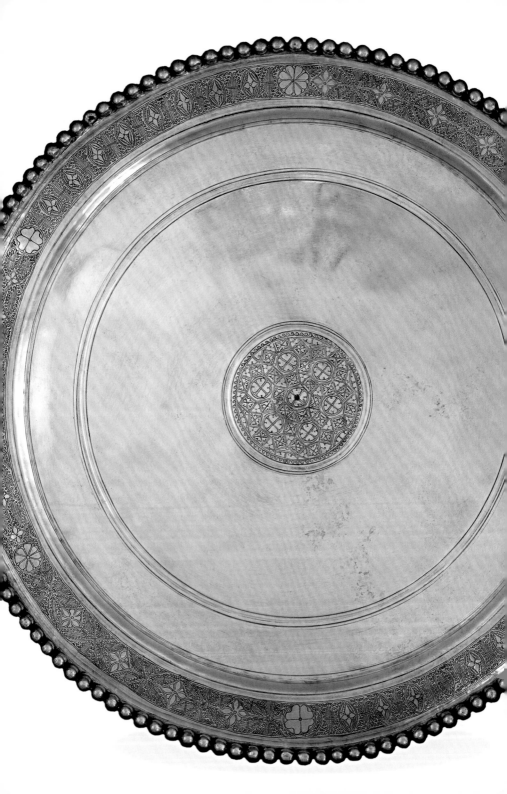

Chapter Three
The ownership and use of the treasure

29 The silver Niello Dish. Diameter 55.6 cm.

Who owned the Mildenhall treasure? Was it an individual or a group of people, perhaps cult followers of Bacchus, or even a family of Christians? The simple answer is we do not know, but we can make some suggestions. One thing that is certain is that the Mildenhall treasure is a rare survival: it is the only late Roman silver dining service ever discovered in Britain, and this in itself tells us that such treasures were not commonplace. (Single silver vessels have been found in Britain, such as, for example, the fine platter known as the Corbridge Lanx, also in the British Museum; see p. 16.) Dining services are, however, known from other parts of the empire. At Kaiseraugst in Switzerland, an enormous hoard of silver vessels was discovered in the early 1960s (with more pieces emerging in 1995), an impressive eighty-five items in total, over 61 kg in weight. Even larger was a hoard found in 1628 in Trier, Germany, in the grounds of a Jesuit monastery. Tragically this treasure was consigned to the melting pot, but it is known that it was composed of about fifty pieces and weighed a gigantic 114 kg.

In comparison to these Continental examples, the total weight of the Mildenhall treasure at roughly 26 kg is rather more modest. Kaiseraugst boasts eleven circular platters to Mildenhall's two. The Mildenhall treasure is still valuable, but how much would it have been worth at the time? This is very hard to judge, but we can get some idea by looking at its value in purely bullion terms – we have to disregard the added value of its fine decoration, because that is impossible to calculate. The total weight of silver in the Mildenhall treasure is the equivalent of about 320 gold *solidi*, the standard gold coin used in the fourth century AD when the silver was made. Literary evidence gives us some information on prices during this period, so how far would 320 gold *solidi* stretch? To pick a few examples at random, with 320 *solidi* you could acquire 320 military cloaks, or about seventeen teenage slave-boys,

43

or employ a middle-ranking church bishop for a year. The richest Roman senators, to approach the issue of value in a slightly different way, could earn 288,000 *solidi* a year, so for them to buy the Mildenhall treasure, or at least its equivalent in silver bullion, would have required them to work for less than half a day. We can contrast this with a junior clerk, who earned 9 *solidi* a year, so would have needed to work for thirty-five years – assuming he never received a promotion, and saved up his entire yearly salary – to accrue enough money to acquire the treasure.

Though crude, these figures suggest that the owner of the Mildenhall treasure was reasonably wealthy and probably had some degree of power and influence in Roman society. He or she was probably a member of the middle or upper classes, perhaps a middle-ranking civil servant, or a military officer, or someone from a noble family who had inherited wealth. Collective ownership by an extended family is also possible – again such a family were very probably members of the middle or upper classes, who owned land, a grand house (or more than one) and other valuables such as sculpture, fine textiles and jewellery. Another possibility is that the treasure belonged not to blood relatives but to a collective group, such as cult followers of Bacchus, perhaps a *collegium*, one of numerous clubs and societies in the Roman world. Many *collegia* were concerned with mutual craft or trade activities, but some were dedicated to special religious worship, which in this case would presumably have involved drinking and perhaps lavish dining. In such circumstances the treasure would probably have been kept in a shrine rather than a private house. The connection with Christianity should also not be overlooked, for although most of the decoration is rooted in the world of Classical myth, as we have seen some of the spoons bear Christian symbols and possibly also inscriptions (pp. 37–8). If, as has been suggested, Papittedo and Pascentia were Christians, then ownership of some or all of the treasure by Christians should not be discounted.

Whoever the owner or owners were, how did they acquire the treasure? Probably the least likely means was

by purchase 'off the shelf' – it is unlikely that one or more visits (for as we have seen, some objects were made at different dates) were paid to a silversmith in a large town, a number of coins handed over and the silver plate carried home. For, though basic goods such as bread, meat and simple pottery could be bought in shops, highly valuable objects were less likely to be purchased 'across the counter'. It is more probable that the owner commissioned the silver and chose the size and number of vessels and the themes to be depicted, perhaps from a pattern book. The owner might even have supplied the raw material, perhaps in the form of coins or other objects, for silver was often recycled. We can be certain that the two spoons with personal names (see p. 37), were inscribed to order, although originally they may have been plain, with the names only added at a later date.

However, the most plausible explanation is that the silver was received as a gift. During the fourth century AD the mining and circulation of gold, silver and other precious substances such as rare gemstones was tightly controlled by the emperor and his court, which was no longer based entirely in Rome but moved around the empire as events required – other imperial capitals included Trier in Germany, Aquileia, Ravenna and Milan in northern Italy, and Arles and Lyons in France (see fig. 2). At each of these places, we know from the evidence of mint-marks that gold and silver were turned into coin. Skilled metalworkers may have been permanently attached to the imperial court, and workshops may have been responsible for cutting coin dies and producing other types of objects, such as silver plate, and possibly gold and silver jewellery too. We have no way of knowing how many silver vessels were produced in this way – it may have been hundreds. Such vessels were certainly used as gifts, as part of a sophisticated system designed to pay the salaries of senior officials, maintain diplomatic relations (normally within the empire, but sometimes outside the frontiers too) and stabilize the social hierarchy. (Of course, the exchange of gifts between dignitaries continued into much later times: in 1880, for instance, a wooden desk

made of timber from HMS *Resolute* was presented by
Queen Victoria to the incumbent US President Rutherford
Hayes, and is still in use in the Oval Office today.) Silver
plate was one element of this Roman gifting system, and
we know this for sure because some silver vessels were
specifically made to record an important event, such as
the tenth anniversary of the emperor Licinius in AD 317,
commemorated on a series of five silver dishes found at
Niš in Serbia in 1901 (one of which is on display at the
British Museum). It is entirely possible that the Mildenhall
treasure, or at least some parts of it, were a gift from one
senior person to another, perhaps even from the emperor
himself to a lower ranking official. In fact it has been
suggested that an official named Eutherios, who served
under the emperor Julian in the mid-fourth century AD,
may have owned the Bacchic plates (see pp. 28–9) because
the name in Greek appears as graffiti on the back of both
vessels. However, it is probably more likely in this instance
that the name relates to the maker of the vessels rather
than their owner.

Once acquired, how was the treasure used? Was it only
intended for display or was it actually used for dining? An
insight into the use of silver plate at this period is provided
by a Gallic (modern France) bishop named Sidonius
Apollinaris, writing only a little later in the fifth century
AD. In a letter to a friend, Domitius, Sidonius talks about
visiting a friend's villa: '[entering] a living-room . . .
which lies open to the lake . . . [there is] a semicircular
dining-couch and a glittering sideboard . . . Reclining in
this place, you are engrossed by the pleasures of the view
whenever you are not busy with the meal'. The 'glittering
sideboard' could be a reference to a silver dining service
similar to Mildenhall, although whether it was for use, or
just for display, Sidonius does not say. All the vessels in
the Mildenhall treasure could have had a practical use:
the two large platters (the Great Dish and the Niello Dish)
would have been ideal for serving large portions of food to
a number of diners. The Niello Dish (fig. 29) in particular
looks perfectly suited for this, as it is largely plain and
completely flat – one can imagine it being covered in a

selection of choice foods. Perhaps the small plates with hemispherical bases were piled high with pyramids of dried fruits and nuts; perhaps the flat-rimmed bowls contained stews, soups or sauces. Perhaps the ladles were used to eat liquid foods and the spoons sweet desserts. The fluted bowl is likely to have been used for water, probably for the washing of fingers during the meal; we know this from studying other vessels of similar design. They seem to have been modelled on scallop shells, which provide the link with water.

In addition, there are depictions in late Roman pictorial art which appear to show silver vessels being used to serve food, although we can rarely be absolutely certain that the artisans were illustrating silver plate – they may have intended bronze or ceramic vessels instead. One evocative example is a fourth-century floor mosaic in the 'House of the Buffet Supper' at Antioch in Turkey (fig. 30). It shows a series of courses arranged on oval or circular platters: one depicts boiled eggs in egg-cups, artichokes and pig's trotters, and in the centre a bowl that contains

30 A buffet platter; detail from a floor mosaic, now in Antakya Archaeological Museum, Antioch, Turkey. Mosaic approximately 2.9 x 2.4 m.

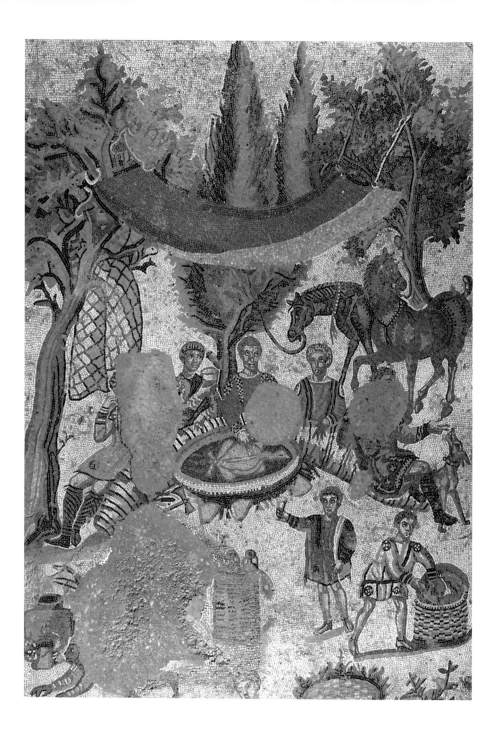

31 A mosaic in the villa of Casale at Piazza Armerina, Sicily. Hunters enjoy an al fresco meal from a large (silver?) platter. Mosaic 5.9 x 7.05 m.

32 An illumination from a fourth-century manuscript of Virgil's *Aeneid*, preserved in the Vatican Museums, Rome. Manuscript folio 33.3 x 33.2 cm.

a red dipping sauce. The mosaicist's use of grey and black tesserae to represent these vessels makes it a strong possibility that silver plate was intended. Another mosaic, part of a series of exquisite mosaic floors in the villa at Piazza Armerina in Sicily dated to the fourth century AD, shows a large platter set before a group of diners sitting on a curving couch (fig. 31). In this scene some hunters, shaded by an awning, have taken a rest from the pursuit of wild beasts and are about to tuck into a plucked and spit-roasted chicken. The fowl is served on a large circular platter, perhaps of silver, although again we cannot be

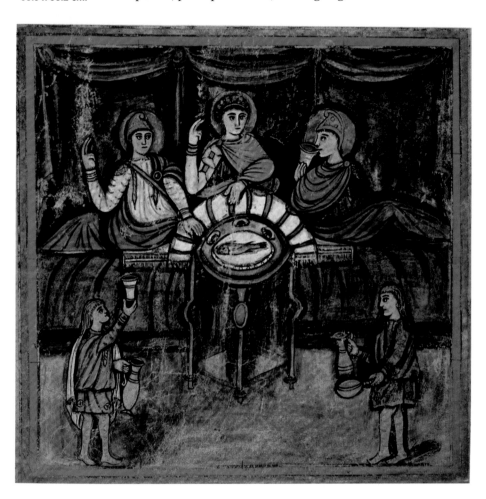

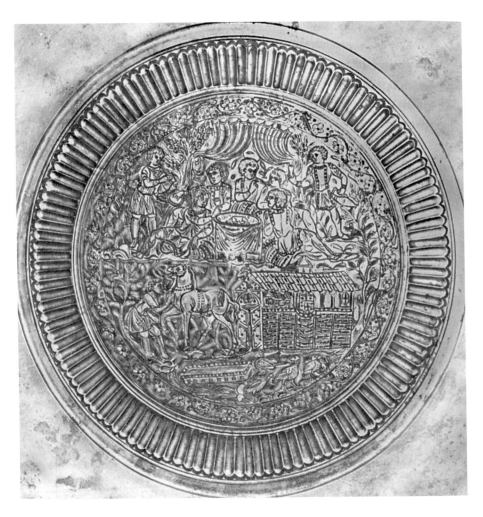

certain. The same can be said of a similar scene, this time indoors, which appears in an illuminated manuscript also dating to the fourth century AD, a copy of Virgil's *Aeneid* (fig. 32). A large fish is presented on a platter, which is rendered in white, but, crucially, with tiny black lines defining the rim. Surely the intention was to show beads, just like those on the rim of the Great Dish?

There are, however, two examples where we can be certain the artist intended to depict silver vessels. In both instances the depictions are part of dining scenes

decorating the piece of silver plate in question: one from Cesena, Italy, shows a platter topped with a small cooked animal and surrounded by reclining diners (fig. 33), while the 'Sevso' Hunting Plate depicts a platter with a fish as part of an outdoor dining scene.

Where did the owners live?

All in all, it seems likely that the Mildenhall treasure probably was used for dining, though only on special occasions, rather than every day. At other times it would have been hidden away or placed on display to be admired. But where did the owners live? This question is also difficult to answer. As soon as the treasure surfaced in 1946, local archaeologists made a connection with the remains of a Roman building found near the supposed find-spot in 1932 (fig. 34). In that year Tom Lethbridge excavated a hypocaust system and found 'large slabs of painted wall plaster'. Although the building apparently consisted of only a couple of rooms, he and his colleague, Gordon Fowler, assumed that the owners of the 'dull little house' (as Lethbridge later described it) must have also owned the treasure. They may have been correct, but the building does not seem to have been quite grand enough for the type of household or *collegium* that is likely to have owned the Mildenhall treasure. This problem applies to much of the region in which Mildenhall lies: archaeological evidence suggests that there are few houses in East Anglia in the fourth century of sufficient architectural pretension to accommodate the treasure.

In fact, the wealthiest part of the province in the fourth century was not East Anglia but the west. Cirencester, the second largest town in Roman Britain, was the official capital of the west and the countryside around Cirencester is dense with luxurious villas and temple complexes. These villas – examples include those at Chedworth, Withington, Great Witcombe and Frocester Court – had large numbers of rooms, bath-houses, under-floor heating, and very fine mosaic floors. The highest number of mosaics from any English county has been found in Gloucestershire,

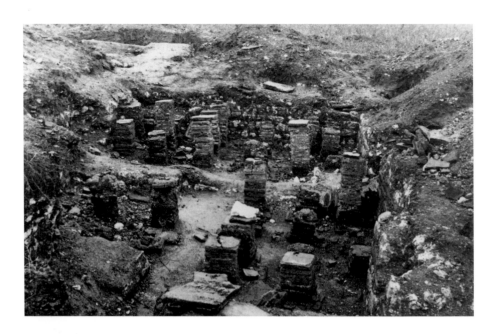

34 The remains of a Roman hypocaust system (under-floor heating) excavated in 1932 near to where the Mildenhall treasure was later discovered.

which boasts at least 250. Not only are these villas appropriate settings for a silver dining service such as the Mildenhall treasure, but the themes of the mosaic floors also echo its decoration. Oceanus, Bacchus and all their attendants, such as sea-monsters, Satyrs and Maenads, crop up with great regularity. So, perhaps one day an individual or a group of people, living in the west of Britain some time in the late fourth century AD, packed up the treasure and headed east to find a remote spot to bury it. This speculation is only one of a number of hypotheses as to why the treasure was buried.

Chapter Four
Why was the treasure buried?

The treasure is laid to rest

Attempting to understand the reasons for the burial of any
hoard of treasure requires archaeologists to behave rather
like detectives investigating the scene of a murder. In the
case of the Mildenhall treasure, however, there is one major
problem: we do not know exactly where the treasure was
buried, so the crime scene, if we can call it that, is unknown.
There is little doubt that the treasure was struck by the
plough of Gordon Butcher and excavated by the tractor-
driver and his boss Sydney Ford (fig. 35) in a field in the
village of West Row near Mildenhall – but the exact spot
where this occurred is simply unknown and may probably
remain so forever.

Why is knowing the exact place of burial so important?
Principally because it might shed light on the motive for
burial. For example, meticulous excavation can reveal
evidence that something has been buried with great
attention, with the objects carefully packed, lovingly
arranged, and neatly covered over. In these circumstances
it might be reasoned that the person burying the treasure
cared a great deal about the objects and, in addition to
their intrinsic value, had a strong sentimental attachment
to them. Perhaps circumstances dictated that their
precious possessions were no longer safe, so they decided
to bury them, in the hope that one day they could return
to collect their goods. We can imagine the owner pacing
out the distance from a recognizable landmark, such as
an oak tree with a particularly distinctive arrangement of
branches, which even years later they could conjure up in
their mind's eye.

Troubled times?

What circumstances, then, might cause someone to
bury such a magnificent treasure? Strong contenders
are external threats, either war with, or raids by, another
people (Rome had plenty of enemies outside its frontiers),

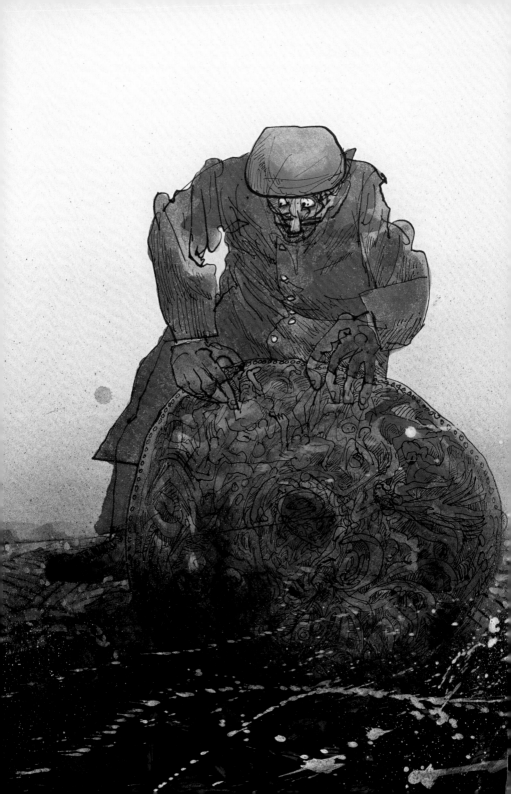

35 Ralph Steadman's recreation of the moment when Sydney Ford pulled the Great Dish from the ground. An illustration for Roald Dahl's story 'The Mildenhall Treasure'. Original drawing 76.2 x 56.5 cm.

civil disruption and piracy or banditry – in some periods even a combination of all at the same time. The Mildenhall treasure was probably buried at the end of the fourth century AD, or possibly the beginning of the fifth – unfortunately no items in the treasure can be closely dated, so exactly when is not known. In Britain, this was a time of great change. By around AD 410, the province was no longer part of the Roman empire. The army and administration had mostly departed. Since the middle of the fourth century Britain had come under attack on an increasing number of fronts. From the north (modern Scotland) came the Picts, attacking the province despite the substantial barrier of the still-garrisoned Hadrian's Wall. From the west came the Scotti, the peoples of Hibernia (modern Ireland), who crossed the Irish Sea in order to launch raids on the west of Britain. And from across the North Sea came the Angles, Saxons and Jutes – and it is the latter groups who have the most relevance to Mildenhall, for a chain of forts built around the coast of East Anglia and Kent, known as the Saxon Shore, appears to have been designed specifically to protect the people of the east of Britain.

So one possible scenario is that to prevent 'barbarians' plundering their precious possessions, the owners of the Mildenhall treasure chose a remote spot and, perhaps under cover of darkness, consigned the dining service to the earth. What happened next? Maybe the owners moved away, or were killed, or returned to reclaim their treasure years later but could not remember where exactly they had buried it – maybe that distinctive oak tree had been chopped down in the intervening years.

An offering to the gods?

Alternatively, careful examination of the burial pit might have indicated something entirely different. We might have learnt, for instance, that the ground in which the objects were buried was waterlogged at the time of burial but had dried out (or been drained) in the subsequent centuries. If so, this might imply that the person burying the treasure never intended to return

36 Opposite Sydney Ford's sketch and inventory of the Mildenhall treasure and how it had lain in the ground.

for it at all. Instead of choosing a place from which they felt their objects could later be recovered, it may be that they watched with satisfaction as the stagnant black waters sucked each piece down into the murky depths. For what motive? Religion, perhaps. For if the treasure had been owned by cult followers of Bacchus and that cult was under attack from others hostile to their beliefs, then the guardians of the treasure, perhaps priests of the cult, might have decided to offer up their ritual vessels to the god as a final votive act. Perhaps they believed in any case that the treasure ultimately 'belonged' to Bacchus, and all they were doing was returning it. In these circumstances, they would not have intended to ever recover it.

Is either explanation correct? Was the treasure buried in the hope of later recovery, or consigned to the earth as a religious offering? Because we do not know the exact find-spot, our chances of deducing the better explanation are greatly diminished. Interestingly, however, we can learn a little from two snippets of evidence from the time of discovery – the only downside is that they rather contradict each other.

Although Mr Ford spent a great deal of time cleaning the treasure during the war years, many of the pieces were still blackened and tarnished when they arrived at the British Museum in 1946. Christopher Hawkes noticed this, and speculated that at the time of the original burial the place was 'inaccessible swamp or swampy pools, exactly suitable for the depositing of a hoard of this kind'. So maybe the treasure *was* an offering to Bacchus and deposited in a stagnant pool.

Mr Ford, however, provides another piece of evidence that points to a different explanation. Around the time of the Treasure Trove inquest, Ford was asked to draw a sketch of how the treasure lay in the ground. What he drew is really rather interesting and detailed (fig. 36). The drawing shows the Great Dish inverted on top of what is probably the Niello Dish, creating what looks rather like a flying saucer, and the six flat-rimmed bowls are in a carefully arranged stack. The Bacchic plates are

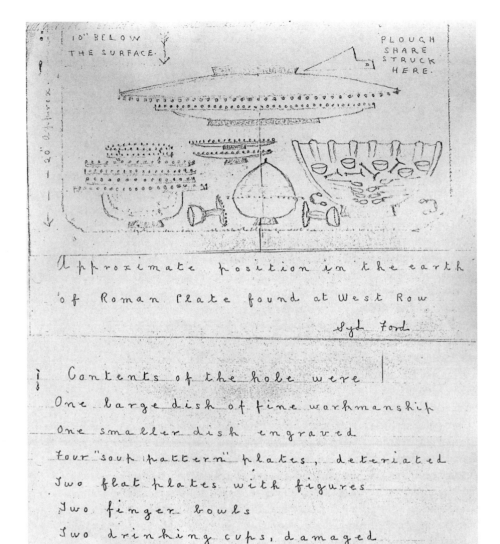

Approximate position in the earth
of Roman Plate found at West Row

Syd Ford

Contents of the hole were
One large dish of fine workmanship
One smaller dish engraved
four "soup pattern" plates, deteriated
Two flat plates with figures
Two finger bowls
Two drinking cups, damaged
One tureen in two pieces
One deep bowl with two handles detached
five ladles with four handles detached
Eight spoons

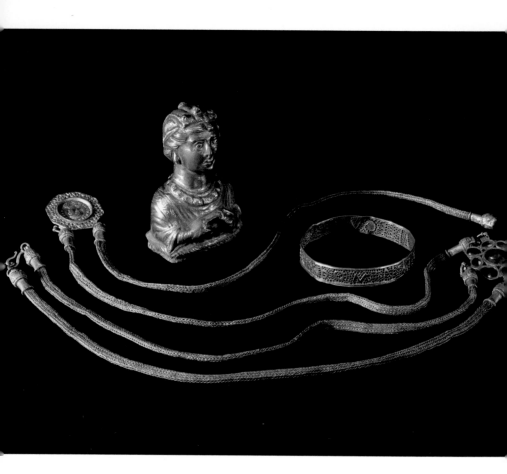

**37 A selection of
the gold and silver
objects from nearby
Hoxne, Suffolk,
another hoard of
late Roman treasure
discovered in 1992.
A silver pepper-pot
(height 10.3 cm),
a gold body chain
(length 84 cm) and
a gold bracelet
(diameter 7 cm).**

also stacked neatly together, and the spoons and ladles
are placed inside the fluted bowl.

Assuming that Mr Ford's sketch is reliable, this
neat, careful arrangement of the objects could imply
that the owners always intended to return to collect
their precious possessions, but it also adds another
dimension: perhaps the hoard had been buried in a
container, maybe a large wooden chest. The sketch
implies that the treasure was in a compact group, so it
may have once sat in a box made of an organic material
that slowly rotted away to nothing. This is not such a far-
fetched idea, because there is another late Roman hoard,
coincidentally found exactly fifty years after Mildenhall,

which we can be certain *was* buried in a large wooden chest – the Hoxne treasure, also from Suffolk (fig. 37). In the Hoxne find the items had been carefully put together, some wrapped in straw, some in textile bags; it too had a set of small flat-rimmed bowls, and these had been stacked in a manner uncannily similar to Mr Ford's sketch (he drew this many decades before Hoxne was found and died long before it was discovered). Therefore, Mr Ford's sketch might encourage us to believe that the first scenario is correct, and that the Mildenhall treasure was buried for safekeeping. That explanation is, on balance, the more credible.

Epilogue

Like all great archaeological discoveries, the Mildenhall treasure tells a story that has no ending. It might one day become clear exactly where the treasure was buried, for we cannot be certain that Ford and Butcher removed every single item from the ground – they could easily have missed something. Even a stray spoon would be enough to resolve the issue of the treasure's exact find-spot once and for all.

We might also at some point discover where the treasure was manufactured, or at least gain a clearer understanding of this. The location of the workshop (or workshops) that produced the vessels is currently unknown. However, by comparing them closely with other contemporary items of silver plate we might be able to narrow this down; for instance, if identical tool marks were found on vessels from different treasures discovered in different locations across the former provinces of the empire. In future there might even be new discoveries with which the Mildenhall treasure could be compared. For decades after its discovery it was the largest Roman hoard of precious metal ever found on British soil, but it was surpassed in 1992 when the even larger hoard of gold and silver coins, jewellery, and small items of silver plate was found at nearby Hoxne (see fig. 37). The world of archaeology is a dynamic place in which new discoveries are constantly being made, all with the potential to shed new light on previous finds.

The Mildenhall treasure may no longer be used as originally intended, as a fine set of silver to impress guests at the dining table. Nevertheless, its imagery of Bacchus and his joyful entourage, and of the sea-god and his fantastical creatures, will always transport us into the Roman world. And the treasure will remind us of how people react to uncertain times – it was the end of Roman Britain that led to its original burial. Centuries later, Mr Ford perhaps found solace from the

uncertainties of *his* time by restoring the silver to its former glory.

The treasure will continue to remind us, too, of how beliefs can change. Maybe one day we will learn more about Papittedo and Pascentia, the probable Christians named on two spoons. They may have been the original owners of the Mildenhall treasure, when the empire was moving away from pagan worship towards Christianity. Until then the inscription that accompanies their names – 'VIVAS', or 'may you live' – seems entirely appropriate for a treasure of such enduring appeal.

Resources and further reading

The Mildenhall treasure is on permanent display at the British Museum. To explore the British Museum collection online, visit the website at britishmuseum.org.

A display devoted to the discovery of the Mildenhall treasure, which includes a set of replicas, can also be seen at Mildenhall Museum (www.mildenhallmuseum. co.uk; tel.: 01638 716970).

For a detailed account of the background to the discovery of the Mildenhall treasure, see R. Hobbs, 'The secret history of the Mildenhall treasure', *The Antiquaries Journal* 88 (2008), pp. 376–420. Although out of print, Kenneth Painter's *The Mildenhall Treasure: Roman Silver from East Anglia* (British Museum Press, 1977) remains an invaluable source of information on the treasure. Roald Dahl's 'The Mildenhall treasure', with illustrations by Ralph Steadman, was published by Jonathan Cape in 1999, and the story can also be found in a collection of stories by Dahl entitled *The Wonderful Story of Henry Sugar and Six More*, first published in 1977. Other sources that may be of interest are listed below.

H.E.M. Cool, *Eating and Drinking in Roman Britain* (Cambridge University Press, 2006)

K.M.D. Dunbabin, *The Roman Banquet. Images of Conviviality* (Cambridge University Press, 2003)

A.S. Esmonde Cleary, *The Ending of Roman Britain* (Routledge, 1991)

P.S.W. Guest, *The Late Roman Gold and Silver Coins from the Hoxne Treasure* (British Museum Press, 2005)

M. Henig, *Religion in Roman Britain* (Routledge, 1995)

R. Hobbs & R. Jackson, *Roman Britain. Life at the Edge of Empire* (British Museum Press, 2010)

C.M. Johns, *The Hoxne Late Roman Treasure. Gold Jewellery and Silver Plate* (British Museum Press, 2010)

J.P.C. Kent & K. Painter, *Wealth of the Roman World, AD 300–700* (British Museum Press, 1977)

R.E. Leader-Newby, *Silver and Society in Late Antiquity. Functions and Meaning of Silver Plate in the Fourth to Seventh Centuries* (Ashgate, 2004)

D. Mattingly, *An Imperial Possession. Britain in the Roman Empire* (Penguin, 2007)

R. Reece, *The Later Roman Empire. An Archaeology AD 150–600* (The History Press, 2007)

C. Thomas, *Christianity in Roman Britain* (Batsford, 1985)

Picture credits

Every effort has been made to trace the copyright holders of the images used in this publication. All British Museum photographs are © The Trustees of the British Museum.

1 British Museum P&E 1946,1007.1-34
2 Map by Stephen Crummy
3 British Museum (part of Gadd archive)
4 Pix Incorporated
5 Courtesy of Sydney Holder
6 Bury Free Press
7 British Museum P&E 1946,1007.5
8 Suffolk County Council
9 British Museum P&E 1993,0401.1
10–14 British Museum P&E 1946,1007.1
15 British Museum P&E 1958,1202.1
16 British Museum P&E 1910,0625.1
17–19 British Museum P&E 1946,1007.2-3
20 British Museum P&E 1946,1007.7
21 British Museum P&E 1946,1007.8
22 British Museum P&E 1946,1007.13-14
23 British Museum P&E 1946,1007.11-12
24 British Museum P&E 1946,1007.15-17
25 British Museum P&E 1946,1007.18, 23
26 British Museum P&E 1946,1007.27-34
27 British Museum P&E 1946,1007.31
28 British Museum P&E 1946,1007.1
29 British Museum P&E 1946,1007.4
30 © Dick Osseman
31 Museo Villa Casale
32 © 2012 Biblioteca Apostolica Vaticana
33 Illustration Stephen Crummy after photo © Gabinetto Fotografico Nazionale
34 British Museum (part of Gadd archive; photo taken by Revd M. Tyrell Green, 1933)
35 © Ralph Steadman
36 British Museum (part of Gadd archive)
37 British Museum P&E 1994,0408.1, 29 & 33